# BLUFF YOUR WAY
# IN
# MODERN ART

## MARINA DANA RODNA

RAVETTE BOOKS

Published by Ravette Books Limited
3 Glenside Estate, Star Road
Partridge Green, Horsham,
West Sussex RHl3 8RA
(0403) 710392

First printed 1990
Reprinted 1992

Series Editor - Anne Tauté

Cover design - Jim Wire
Typesetting - System Graphics Ltd
Printing & Binding - Cox & Wyman Ltd.
Production - Oval Projects Ltd.

Translated from the French by:
Paul Bahn and Catriona Tulloch

The Bluffer's Guides are based on
an original idea by Peter Wolfe.

For My Mother, Cecilia.

# CONTENTS

# WHAT IS MODERN ART?

Art has always been modern. The pyramids of Egypt and the Roman Forum were very up to date in their time. Today this is a must; you have to be modern at all costs. Like Alpha Romeos, modern art quickly goes out of fashion: indeed this is one of its outstanding characteristics. It 'represents its time', a fact which increases its commercial value.

The art of yesteryear strove to create an illusion of reality, to achieve a feeling of beauty and harmony. The bluffer can knowingly slip into conversation that, in the past, artists were seeking to express the ideal of beauty, in stark contrast to present-day preoccupations.

Modern art really began with the expression of subjectivity, of feelings of tension and crisis. Most people are totally incapable of liking it, and this mental block is displayed quite democratically by every social class. In general, people are highly conformist; modern art disturbs their sense of convention, unless of course it brings them prestige and wealth.

For artists, being modern means showing in a totally new way what others before them have already been doing for ages. Few of them succeed. In desperation, they adopt prefixes such as: neo-, new- or, better still, nouveau-, post-, trans-. They only create neologisms. Erudition is admirable, but it seldom leads to masterpieces.

The sculptor Pol Bury, creator of numerous fountains from Paris's Palais Royal to the Seoul Olympic Games, has expressed the modern artist's main aim: 'My procedure is a little like that of Cézanne looking at the Sainte Victoire mountain and changing the traditional image one might have of it. It's a way of showing familiar places in a new light and, after giving them a different viewpoint, of seeing them better or less well.'

# How to Become a Modern Artist

Dali thought a modern artist was a poet: 'Don't you think that we, the artists, are the only poets, the only ones who truly create new poetry'? He wrote this to Federico Garcia Lorca himself.

Picasso invented his own imaginary collection: 'What is a painter? He is only a collector who wants to assemble a collection by making his own versions of the pictures he likes by other artists; that's how I begin; it develops from there.'

However, even if you're not driven by an inner absolute necessity, there are still some methods you can adopt to make other people think you are or will soon become well-known:

– Believe that a shape has more aesthetic value the less you can recognize it.
– Paint with one colour and always the same one.
– Gather some garbage, and arrange it like knick-knacks on a shelf.
– Go to a scrapyard, crush together a few tons of scrap-iron, and build a sculpture, after making it known you are preparing a great work.
– Patiently spend several decades painting white squares on white backgrounds, black circles on black backgrounds, or stripes of equal length, in order to acquire a style and a name.

If what you've done is extremely boring, then you're well on the way to becoming a successful artist.

In order to succeed, you must above all:

• be lucky
• persevere
• be prepared for people to laugh at you, and still remain convinced of your own genius.

# ART MOVEMENTS

From the start of the 20th century, each successive artistic trend has forcefully affirmed what has been repudiated just as emphatically and noisily by the preceding one in a symbolic conflict between the generations.

The bluffer can say things like 'Marcel Duchamp destroyed the subject of the picture by letting the spectator recreate it himself', or 'Yves Klein reduced his work to the presence of the single colour'. But you'll find it difficult to instil an appreciation of this kind in someone who is not already a confirmed devotee. Better stick to a general formula designed chiefly to display your knowledge of the subject: this is precisely what critics do.

## Expressionism

Painting in bright, violent colours the most twisted forms possible.

Expressionists brought the first great radical upheaval in the concept of the work of art and its subject. Contemporary painters never cease to rediscover it today, under the more fashionable label '80s' or 'post-modern' to make it seem brand new. As art critic **Hertwarth Walden**, founder of the movement, said without too much false modesty: 'We call this century's art expressionism to distinguish it from everything that isn't art. We are well aware of the fact that the artists of past centuries were also seeking expression; they just didn't know how to formulate it.'

If the painters of the group **'Die Brücke'** (the Bridge), originating in Dresden in 1905, wanted this name to signify a bridge between their art and the future, they

succeeded brilliantly: social disasters and pictorial revolutions make them, even today, as up to date as ever.

**Ludwig Kirchner** and **Eric Heckel** were among the best known members of this group, so the bluffer will emphasise the contribution of the more obscure **Karl Schmidt Rottluff** or **Fritz Bleyl**, painters who, like many others, normally just languish in books.

Of Die Brücke's artists, **Emil Nolde** is the best known. Whereas many expressionist painters committed suicide at the start of nazism, Nolde declared himself to be a convinced national-socialist. There are no ethics in art. Unfortunately for him, Hitler – a well-known jobbing painter himself – considered his works to be as degenerate as those of his comrades, with their tormented shapes, and Nolde was forbidden to exhibit anything at all during this dark period.

The cosmopolitan **Blaue Reiter** movement was founded in Munich by **Kandinsky** after he left Russia; he brought his friend **Franz Marc** into it, as absolutely nothing is more important in art than friendship or enmity. Critics wanting to impress the public seek the most complex etymological origins possible for artistic trends. True artists, however, prefer simplicity: the only thing Kandinsky had to say about this movement's name was: 'Marc and I adore blue; Marc likes horses and I like riders, so the name of Blaue Reiter, the Blue Rider, seemed appropriate.'

For an artist, living in Oslo is an advantage: there's not much artistic competition there. **Edward Munch**, the 'monstre sacré' of expressionism, is well rewarded for his genius in the shape of a gigantic museum, devoted entirely to his work. The accomplished bluffer will refer to Munch's most famous picture as 'Skrike' (the original Norwegian, rather than the 'Scream', 'Shriek' or 'Cry') which sounds as scary as the painting itself, and mention in passing his far more interesting and impressive

engravings on wood. This carries the implicit impression that you know the whole of his *oeuvre* by heart – which, naturally, is the sole aim of such a conversation.

Expressionism underwent many changes from different influences, for example, the **Fauves** (wild beasts), **Matisse** and **Derain**. They were given this name disparagingly by Louis Vauxelles, famous critic of the period, who on seeing their works at the Autumn Salon, said he felt as if he was locked in a cage of wild animals in a zoo.

# Cubism

A group of painters who systematically schematised everything around them, preferably household objects, totally unrecognizable but for the title.

Born in **Picasso**'s studio, Cubism started by shocking even the future cubists themselves. When **Braque** paid his first visit to the Master, he told him 'In spite of all your explanations, the effect of your painting is like telling us to drink petrol.'

Bluffers can score some points by declaring that the spiritual father of cubism was **Cézanne**, who said he was searching in nature for the cylinder, the cone and the sphere (none of which is particularly easy to find there). He shares this paternity with African art; however the latter is discreet, publishes no manifestoes, and is happy to remain anonymous, so it holds very little interest, if any, for modern art critics.

**Braque**, an early convert to cubism, unambitiously declared a few years later: 'For me cubism, or rather my cubism, is a means I created for my own use, the purpose being to bring painting within reach of my own talents.'

The masterpiece of this kaleidoscopic movement, which showed the same object from different angles will always

be Pablo Picasso's 'Demoiselles d'Avignon'. You should know that these were neither demoiselles nor from Avignon, but women from a Catalan brothel in Avignon Street, Barcelona. They were undoubtedly open to a wide range of angles, not all of them geometric in nature.

**Juan Gris**, another Spanish founder of cubism, is easily recognizable from his paintings which are as grey as his name. He chose this pseudonym because his modest personality came closest to this colour. Bluffers can dazzle their audience with the fact that he was also a freemason. Mystery always attracts attention.

The movement's name comes from a detractor who could see nothing but cubes in the work: **Louis Vauxelles** reproached Braque for his obsession with geometric forms.

Cubism first reached the public in a room of the Salon des Indépendants in 1911. You should know that it wasn't represented there by its originators, as you might expect, but by painters who had been influenced by them. Among them were **Albert Gleizes**, **Fernand Léger** and **Henri Le Fauconnier**. Picasso, Braque and Gris did not exhibit in the Salons at that period, but in the smaller Kahn-weiler gallery.

You should emphasise the crucial difference between **analytic cubism** and **synthetic cubism**: "analytic cubism dangerously sacrificed the unity of the object to its veracity, whereas synthetic cubism is liberated from the slavery of local tone." Nobody will dare say they haven't the faintest idea what you're talking about.

Mention your love for **Jacques Villon**'s luminous works; say that, on seeing the Eiffel tower, you can't help experiencing a flashback to **Robert Delaunay**'s painting that depicts it prismatically. This will distinguish you straightaway from the simple tourist who goes travelling just for fun.

Sadly, even a movement like Cubism, with lofty

aspirations far removed from vulgar reality, remains subject to lady luck. It died with the outbreak of war in 1914: it just faded away as artists went off to join the army.

If you meet an opponent of cubism quote Chagall: 'When meeting the proud cubists for whom, perhaps, I was a nothing, I used to think: let them eat their fill of their square pears on their triangular plates.'

# Futurism

The same thing as cubism, but with some movement added, and the prospect of a better future.

The irresistible optimism of some Italian painters attached to cubism gave birth to futurism. In their bright new manifesto published in 1909 in Paris, the art mecca of the day, futurists announced to the world: 'We want to free Italy from its huge mass of professors, archaeologists, guides and antiquarians. We want to rid Italy for ever of the endless museums that cover it like countless cemeteries.' Laudable intentions, but ones which soon led the same subversive artists to fill the 'endless museums' with their own works.

These likable rebels, **Severini**, **Balla** and **Boccioni**, use so much movement in their canvases, it makes your head spin.

They wrote a lot of funny, virulent manifestos, such as:

– 'Let's kill the moonlight'
– 'Manifesto against old-fashioned Venice'
– 'Manifesto against Montmartre'.

In contrast to their Parisian colleagues they didn't exclude the expression of feelings from their artistic views. Balla wanted to translate in a pictorial way 'the

11

simultaneity of the different states of the soul, of emotional memory.'

In short, they gave birth to sentimental geometry; typically Latin, and extremely touching.

# Vorticism

English version of the preceding two squint-eyed views of the world.

This futurist movement was founded in 1914 by the British painter **Wyndham Lewis**. He defined it only as 'everything I've done and said at a certain time.' Such bold declarations are very useful: even if they're not believed, they tend to be remembered.

The manifesto appeared in the review *Blast*, which lived up to its name when war broke out after only two issues had gone on sale. The war also put an end to vorticism itself after the 1915 exhibition at London's Doré gallery, which included painters **William Roberts** and **David Bomberg**. Stress to your audience the underestimated rôle armed conflicts have played in modern art history. They give rise to, and destroy, any movement they like.

Remember that the sculptor **Epstein** and the poet Ezra Pound were vorticists. Not a lot of people know what that means, so you will immediately stand out like a dancer in a rugby scrum.

# Constructivism

Works of art in which the subject disappears in favour of a mass of simple shapes and colours.

As positivist as it was ambitious, this movement, born in Russia in 1920, imposed itself on the whole world at dizzying speed.

**Malevitch** wanted to found a synthesis of the arts by cleansing them as far as possible of their previous content until he attained the notorious white square on a white background, a point beyond which it is very difficult to go. His paternity of this concept is supposed to be so valuable that he was endlessly copied.

Surrounded by ideology from the start, the group was immediately torn apart: the 'non-objective' opinion of Malevitch, **Pevsner** and **Gabo** was opposed by the **Productivists** grouped around **Tatlin**, who also (as if that wasn't enough) wanted to serve the proletariat. An ideological conflict worthy of the Russian Revolution broke out. The split widened. Naum Gabo made a public declaration: the **Realist Manifesto**.

The Productivists' answer was not long in coming; their platform asserted 'Art is a lie that serves only to hide humanity's impotence. Communist forms of constructive edification must bring about the unity of art and technology through the close integration of intellectual production with industrial production.' A new man was born with this jargon: the artist machine.

Within this puritan way of thinking, pictures are composed of circles and squares born of the most optimistic technological models devoted to the new gods: Science, Reason and Progress. However, this rigorously functional simplicity displeased Stalin's régime. For the edification of the masses, he much preferred socialist realism to these bourgeois deviations.

So the Constructivists emigrated, taking their concepts with them to Germany and the United States. Naum Gabo spent some time in exile in London. The true lover of modern art will not forget to emphasise that Pevsner was his brother.

# The Bauhaus and Geometric Abstraction

A typically Germanic way of transforming modern art into an annex of applied technology, through a school and a method.

This twin brother of Russian Constructivism was founded at Weimar by **Walter Gropius**, better known perhaps for his love affair with Alma Mahler after the death of her husband.

Although at the forefront of modernism, the Bauhaus was inspired by medieval guilds. In this school there were no teachers, only Masters and Disciples: the artist was supposed to become an artisan. 'Architects, sculptors, painters, we must all return to craftsmanship . . . with no class distinction to raise a wall of pride between artists and artisans' – this was the kind of stuff taught by Gropius, the unwitting founder of contemporary new elitism.

The **Bauhaus**'s instructors remain prestigious, but their exact roles are usually forgotten, so the bluffer must pretend to be familiar with them:

– **Kandinsky** presented fresco techniques.
– **Paul Klee** taught stained glass and weaving. Remember his pictures are pretty close to stained glass windows.
– **Lionel Feininger**, the painter of light, taught painting together with theories of form.

Spiritual children of the Bauhaus are now countless. Apart from the **New Bauhaus** of **Lazlo Moholy Nagy** at Chicago, Geometric Abstraction, Conceptual Art, Minimal Art and the so-called Kinetic arts have all used its precepts again and again. This enormous family never stops growing.

It offers:

- A theoretical framework as abstract as it is impossible to digest
- A treatment of the work that is cold, quick and easy to carry out.

Another sign of the extreme severity of the times, **Piet Mondrian** in Holland also believed art could no longer exist outside the everyday environment which, for him, was the only artistic truth; he evolved from a stylised symbolism to grid patterns as severe as roadsigns.

In 1922 the Hungarian Lazlo Moholy Nagy discovered the best way of creating without tiring oneself: he was a founder of **Conceptual Art**. Thinking a thing becomes a work of art in itself. Seeking anonymity in the method of execution, he ordered by phone a group of paintings on enamel from a signboard manufacturer. 'People are convinced that they must demand only work done by hand; they believe the manual process is necessary to a work of art. In fact, compared to the mental process of this genesis, the question of its execution has no importance at all . . .' In such an equation, an artist's fame becomes inversely proportional to the anonymity of his work. Curiously enough, nobody has yet proposed that the artist, too, should remain anonymous.

These manufactured items, like plastic glasses, exhibit as **Ready-mades**. But not everybody is allowed to show ready-mades. Beforehand, you have to be called a great artist. This prevents street-sweepers turning their hand to it as well.

The tone in which lovers of modern art approach **Geometric Abstraction** will decide whether the audience listens attentively or believes it is really a joke.

# Dadaism

Everything you've always longed to say or do without ever daring to.

The healthy giant raspberry blown by Dadaism swept away the preceding artistic schools of thought like autumn leaves. **Nonsense** in itself became modern and managed to remain so. Today, more than ever, Dadaism represents the spirit of this century.

With Dada, the numerous '-isms' of the 20th century were reduced to their simplest phonetic expression. This group alone refused to constitute a movement, which was not the least of its merits.

**Tristan Tzara** was born to a Jewish family in an obscure little village in Romanian Moldavia. His real name, now totally forgotten, was Sammy Rosenstock, so right from the start he had every reason in the world to take nothing seriously. Worried about his flights of fancy, his parents sent him at the age of 17 to study in the austere town of Zurich to ensure he had a good training and to knock some sense into him. Hence, without knowing it, they were responsible for Dadaism's creation. As soon as he arrived in Zurich in 1916, Tzara, together with his friends the sculptor **Hans Arp** and the painter **Marcel Janco**, founded the Dada group at the **Cabaret Voltaire**.

Its success eventually spread all over the world, but at first the group was universally disparaged. Treated as pacifist agitators, or as enemy spies during the 1914-18 war, these artists had all the patriotic and respectable people of the world against them. This is tantamount to certain achievement, and assures you of ultimate artistic fame, but in the meantime it does make your daily life extremely difficult.

The Dadaist manifestos were published at the authors'

expense. Their games of 'objective chance' took the place of the usual declarations of faith.

The group's name was chosen at random by opening the pages of a dictionary: Dada, 'horsey' for children in French, was also a double use of the word 'yes' in Russian and Romanian, so etymologically it stressed a negative.

These artists enjoyed **automatic writing**, which consisted of giving free range to one's associations of ideas, no matter how foolish. They loved the game of the 'exquisite corpse': an association of superimposed drawings made by different people, ignoring each other's preceding sketches, and hence building up a collective work as funny as it is peculiar.

Tzara, a poet as well as an artist, created strange **collages** little known to the public; they were the subject of an exhibition at Paris's Grand Palais.

**Man Ray**, **Marcel Duchamp** and **Francis Picabia** blew the Dadaist raspberry in New York, already the world's most bizarre city. After the **Armory Show**, organised in 1913 by **Alfred Stieglitz**, Europe's most despised artists were accepted in the United States as representing the new western culture. This illustrates Marcel Duchamp's declaration: it's the spectator who makes the picture.

'Who did Dada'?, asked Man Ray: 'Nobody and everyone. As a baby I did Dada and mother spanked me. Now everybody claims to be the father of Dada. This has been going on for thirty years now, in Zurich, Cologne, Paris, London, Tokyo, San Francisco, or New York. In 1919 I legalised Dada in New York . . . Just once; that was quite enough . . . It was a dadadate.'

If you wish to pass yourself off as a specialist, ask your companions Man Ray's real name. It was Emmanuel Rudnitsky. You can be sure nobody remembers it these days, and be suitably astonished at their ignorance.

# Surrealism

Artistic productions that look like the materialisation of a psychotic's dreams as deciphered by a clairvoyant.

When **André Breton** discovered Dadaism, he wanted to transform it into a national artistic movement, with a charter and a political goal: surrealism.

He wished to make it official, respectable, and above all, to direct it personally. Waves of people successively joined up and were excluded, just like the methods of the Stalinist parties at the time.

Because he had refused to join André Breton's committee, Tzara was denounced as a 'publicity-seeking imposter just arrived from Zurich.' This statement brought him a declaration of support from 45 Parisian intellectuals, but he still did not gather them into an organisation.

Breton wrote the surrealist manifesto; few people, however, know that Leon Trotsky was a co-author. Breton called the group's journal *The Surrealist Revolution*; until his own exclusion from the party, he tried his best to reconcile surrealism and communism: since the latter was not renowned for its sense of humour, he failed.

Fortunately **Salvador Dali** never shared this aim. He was quickly kicked out of the group and given as a nickname the anagram 'Avida Dollars'. 'I cared as much about Marxism as about a fart,' he said.

Proud of being catholic, both apostolic and Roman, he aspired to classicism: 'I think I shall manage to be a classic as well as a paranoid.' Too lucid to find truth other than in madness, he built up the **method of critical paranoia** throughout his life and his work. *How to become Dali* is the ideal guide for the megalomaniac. In his youth, with a delectable, morbid enjoyment, he identified himself with Saint Sebastian and wrote an essay on him; his huge novel *Hidden Faces* tells of the stimulation of orgasm

through abstinence and frustration.

A bluffer of genius, he turned knowledge into absurdity, and pride into involuntary modesty 'The only difference between me and a madman is that I'm not mad.' But avoid imitating his example too often if you want to hang onto your friends. People may be willing to tolerate absolutely anything, but only if they can comfort themselves with the thought that you're an 'artist of genius.'

Dali remains the only artist who will never be reproached for not having lived according to his convictions. His house at Cadaqués seems to have sprung out of one of his canvases; it is dominated by an immense black cypress tree opposite the door, growing inside the wreck of a fishing-boat. Camels and gigantic eggs stand on the roof.

A modern art lover must pretend to know everything about the origins and the end of this genius of surrealism. For the purpose, you can cite his passion for the portrait of Ana Maria, his sister, seen from the back leaning out of a window: it hangs in Madrid's Museum of Contemporary Art which relatively few people bother to visit.

A true rebel has to start very young. Accused of political agitation, Dali was quickly expelled from the School of Fine Arts at Madrid, and even spent 35 days in jail. At Figueras he met **Miró**, who introduced him into the glittering Parisian circles.

Dali balanced his cult to himself equally with the adoration he gave his wife **Gala**, a kind of volcanic Russian divinity. He poached her from Eluard, her husband, after going down on his knees before her, covered in blood and goat droppings as a sign of humility. She was so touched (in more ways than one, no doubt) that she declared 'My child, we shall never leave each other again,' and indeed she remained with him until the end of her days, rocking him to sleep when he had insomnia. When she finally did leave him, against her will, on the

19

day of her death, the painter was plunged into a profound depression from which he never recovered and which put an end to his artistic output.

At a time of worldwide rationality, surrealism wanted to be visionary. The magic comes in the *oeuvre* of **Victor Brauner** who inherited a feeling for the occult from his father, a skilled devotee of table-turning. But it turned to tragedy when, during a quarrel between **Dominguez** (a surrealist painter from the Canary Islands) and a friend, a splinter from a bottle cost him an eye, shortly after he had painted an eyeless self-portrait.

Another astonishing premonition of that kind happened to **Giorgio de Chirico**. He painted an injured Apollinaire. Soon afterwards, the poet was gravely wounded in the head in the war.

Although the first international exhibition of surrealism took place in London in 1936, happenings, readymades, changing the meaning of objects, perversion of concepts through an exquisite Dalinian menu all triumphed in 1938 at the great International Exhibition of Surrealism at the Galerie des Beaux-Arts directed by Georges Wildenstein.

Dali set up his 'Rainy Taxi,' with water flowing through the roof, and placed in it 'a snobbish and surrealistic lady' dummy on whom 200 Bourgogne snails were wandering around. The public was dissuaded from sniggering by hysterical laughter, recorded in a lunatic asylum, being broadcast loudly from a hidden phonograph.

Surrealists had one point in common: they all worked in Paris at one time or another during their lives. Not even **René Magritte** was an exception to this rule: after leaving the secret **Mystery Society**, a group of Belgian surrealist painters, he settled in the French capital.

His palette was as nordic as Dali's was Mediterranean – one can't escape one's roots. The 'Raped Woman' carries her body on her face, the 'Empire of Light' wakes in

darkness inside a house in daylight, in front of which shines a single lamp-post. Birds become clouds, rocks levitate, the sun emerges from the centre of a landscape. This curious world is certainly disturbing, but collectors found it far less so once it became valuable.

You might suggest, with the right note of melancholy in your voice, that the suicide of the artist's mother left a visible mark on Magritte's *oeuvre*. Society likes psychological explanations. Like many people you have visited the Magritte room of the Modern Art Museum in Brussels, so it is better to mention the sumptuous exhibitions that are regularly dedicated to this artist by the **Isy Brachot Gallery** in Paris and Brussels. Galleries often own far more works by one particular artist than museums do.

# The Paris School

Group of foreign painters not belonging to any previous artistic movement, who spoke French with a strong accent, and who settled in Paris after wandering round the world.

The Paris School is a polite term for the foreign painters of **Montparnasse**, Jews and Slavs for the most part, who are thus linked in one way or another to French painting.

These artists simply wanted to express human feelings. This led to them being considered old-fashioned. It was trendy at this time in the artistic circles of the French capital to despise traditional objectivity.

**Modigliani** – Modi to Italians, Dédo to close friends – was invited by Picasso to join his group. However, he objected 'I don't feel like it, you're someone who manages others, a leader; I'm too afraid of being tempted to follow you, to walk in your footsteps.' He chose instead to study sculpture, working in the studio of **Brancusi**, a solitary Romanian bear of peasant origins who wasn't too keen on

founding any kind of school of modernity. (Bluffers can pounce fiercely on those – virtually everyone, in fact – who say 'Brankoozi', and explain that the correct pronunciation is 'Brankoosh'.) According to the Parisian art critic Gilbert Lascaux, this sculptor made a portrait of James Joyce in the form of a spiral. When he saw it, the writer's father exclaimed 'How the little lad has changed.'

Modi was handsome. According to Picasso, he behaved like a gentleman dressed in rags. He did his drawing in cafés, his mistresses' houses, or his friends' studios. He drank a lot, and sometimes smoked hash. Carrying a copy of Dante in his pocket, he would stop his friends and translate verses to them, whether they liked it or not. At the **Café du Dôme** or at **La Rotonde** he offered his drawings to customers, saying 'I'm Modigliani, a Jew, 5 francs.'

As one might expect, this direct method of presenting himself did not endear him to the clientele of these respectable establishments. Sometimes, he swopped a drawing for a glass, and with an archivist's care wrote at the bottom of the paper 'Drawing for drink'. He composed verses: 'Laziness is my loveliest mistress.' People were already used to thinking that painters didn't really work.

'To draw is to possess, an act of knowing and possessing that is surer and deeper than sex, that only dreams or death can really give.' Modigliani's figures are easily recognizable, with their eyes made empty from looking inside themselves. You might add that his nudes are nuder than nude. Renoir also preferred to paint nudes, finding them more expressive than landscapes. People are always interested in the bohemian life of truly successful painters.

Modi, like Picasso, worked fast – Picasso said 'one can never work fast enough.' Nothing could be better guaranteed to shock Sunday painters who spend the whole day in front of their subjects, or artists who imagine they're

painting when they're merely copying.

Surrounded by a crowd of Slav artists in Montparnasse, Modigliani became friends with **Soutine**. A shoemaker's son from Russia, he regarded Modigliani much as a dog regards its master: a faithful shadow. He thanked Modigliani for giving him self-confidence – which was a bit odd, as both of them were depressives.

Soutine deformed his people like pieces of raw meat. This, you should maintain is where the beauty and charm of his works lie. He preferred to paint his pictures on old 17th century works that he picked up cheaply in the fleamarket; they were thus already grounded in history.

Unfortunately he didn't have the strength to leave Paris for the United States where his work was greatly admired, and died during the war of a perforated ulcer, on the run (as were other Jews) from the police. His very pious girlfriend had previously treated him with Lourdes water.

**Pascin** was the king of this generation of Montparnasse artists. Bulgarian by origin, he was known throughout Paris for his generosity. He started out by illustrating the Munich satirical newspaper *Simplicissimus*, before devoting himself to his favourite models, naked and half-undressed prostitutes. There is no amorality in art. Being very attractive, he made many amorous conquests and married Hermine David, who was also a painter. Indeed, her pictures seem to be close copies of his. This often happens in such cases: feminism had not yet arrived.

Ironically, aged 45 and at the very summit of his glory, Pascin committed suicide. When a retrospective exhibition of his work was about to open in a Parisian gallery, he was found hanged in his studio. Anyone who believes that an artist is primarily motivated by glory will find this very disappointing.

**Chagall** came from Vitebsk, bringing with him in his

luggage the world of the ghetto that he tried to hide in his canvases. Point out that this is indeed where it still survives best.

He preferred to call himself Marc so as to pass unnoticed more easily, but his real name was Moses. His family background was extremely modest, and his parents hadn't the faintest idea what painting meant – they often used his pictures as rugs or blankets: it can get pretty cold in Russia. 'My sisters thought the pictures were for wiping their feet on, especially those painted on thick canvases.' Nevertheless, the family sent him to study painting under Jehouda Penn, an obscure local artist from his home town, before following Leon Bakst's classes in St Petersburg.

In Paris he remained unknown for a long time: when he came to present a series of works to the collector and patron Jacques Doucet, to whom he had been warmly recommended, Doucet had his servant tell him 'We don't need the greatest colourist of our time.'

Long afterwards, the Minister of Culture, André Malraux, asked him to decorate the ceiling of the **Paris Opéra**, in order to rejuvenate this venerable monument. Having already reached the age of 60 and achieved world renown, Chagall could no longer upset anyone – though there are still some defenders of the old ceiling, now covered up, who would invoke the protection of cultural heritage.

Less well known and therefore good bluffer's material are the '3 Ks': **Krémegne**, **Kisling** and **Kikoïne**. The works of the other artists of the Paris School now fetch fabulous sums, but one can still discover the 3 Ks at public auctions, where it remains possible for ordinary people, albeit with a penny or two, to acquire one of them.

Kisling shares with **Marcoussis** that taste for heroism which drove so many foreign artists of their generation to join the French army at the start of the First World War. They hoped to be considered real Frenchmen if they

24

managed to come back alive. Nationalism at this time was strongly recommended, especially for foreigners.

Even more exotic than the others, and thus an excellent artist to espouse, was **Tsugouharu Foujita**. From Japan he brought the art of the Oriental print, transposed onto canvas in transparent oils. He studied at Tokyo's School of Fine Arts but decided to settle in Montparnasse. There he painted still-lifes, portraits of slender women, or cats with bristling fur. The latter, in particular, quickly gained world renown. Their popularity quickly exceeded that of any of the painter's other subjects: a pretty portrait of a woman holding a little mog at present commands £250,000.

Honoured in Parisian salons, Foujita found that his Buddhist beliefs vanished little by little until his unexpected conversion to Catholicism in Rheims cathedral. The first kings of France shared the same idea.

For a baptism name he chose 'Léonard', a true hommage to the other God of painting. This relatively late revelation led him to build a chapel at Rheims: *Our Lady of Peace*, a little church that he decorated for nothing. Hardly anyone knows it exists, so this is what bluffers know best and love to talk about. In its frescos the Virgin is as venerated as the vineyards that surround the chapel, vineyards which gave the world Champagne. His saints with their narrow eyes and prominent cheekbones remind one curiously of lost Botticelli figures with an Asiatic slant.

# Realism

What many artists return to after having a good try at something else.

An international movement, cyclical in nature, Realism aimed to re-establish an objective view of daily life

through figurative work after the endless variations of abstraction. It covers a wide range of approaches and different periods, but as painting it was original because it resembled a photograph.

The favourite subjects depicted come mostly from the industrial or urban world. The people look like those you pass in the underground at rush-hour after a hard day's work. The landscapes appear empty most of the time, unless they're crossed by such exciting things as a tractor, a railway line or a motorway.

The American painter **Thomas Hart Benton**, who practised this doctrine and was a leader of the movement, summarised it as follows: 'A windmill, a heap of scrap-iron or a Rotarian are more meaningful to me than Notre Dame or the Parthenon.'

This pictorial movement wants the spectator to believe that cities of skyscrapers or factories constitute the real artistic revelations of modern times.

Fellow American **Edward Hopper** is the best known artist of this school. In his pictures, everything seems to be in freeze-frame forever. At the beginning of the century he travelled in Europe for a while, but none of the artistic research underway there at the time seems to have captured his interest.

You can easily single out his works by their people, often seen from the back, lost in vast, typically American rooms, comfortable, but impersonal. He had a predilection for equally empty and rainy landscapes. He started his career as an illustrator, and it shows. He never changed style. In fact, this was hailed by critics as one of his great qualities: it meant they could avoid the trouble of having to ask themselves new questions. Hopper painted even faster than Picasso, for after his death in 1967 he left an American museum no less than 2000 works.

If you want to make people think you adore him, just mention your recent visit to New York's Whitney

Museum of American Art. You really don't need to go there for this purpose, as long as you are able to observe the world around you, and enjoy taking good photos.

Germany also went through a devastating flirtation with realism during its national-socialist period. Blond parents proudly held their chubby children in their arms and picked apples in immaculate orchards. Realism was the **Reich's official artistic movement**, embodying true German art in contrast to expressionist works which were considered too twisted to merit the designation aryan.

Dictators are particularly fond of realistic painting. Around the 1930s, Stalinism invented its own realist movement: **socialist realism**. The painters who took part in this movement disappeared from the scene as fast as they appeared. As state artists they worked only to order and turned out official art as readily as cinema posters or the party's propaganda figures.

The workers and peasants in the paintings, always depicted at work or coming back from work, worthy and proud, the embodiment of communism, firmly incited the onlooker to emulate them instantly. Any other view of the world was strictly to be avoided if the painter wanted to return home safely.

Appearing simultaneously in America, Germany and the USSR, realism was conceived alternatively as a criticism or a social approval depending on the intellectual or political interpretation of the viewer.

In Holland, **Pyke Koch** renewed the theme; he recalled Vermeer, his symbolism lightly tinged with human failings and otherworldliness. Living in isolation in Utrecht in a small castle, he often used his wife as his model. This is a golden rule among artists – they like to have the model entirely at their disposal.

Few people outside Holland know about this painter, apart from museum curators. He is therefore a boon to bluffers, who will cite his circus pictures or his female

portraits presented at the Beaubourg exhibition of Realisms, which of course one couldn't possibly have missed.

# Abstract Expressionism

Throwing onto an immense canvas, as fast as possible, great splotches of paint that are supposed to express one's thoughts.

Since geometric abstraction had become somewhat repetitive – although it's very much alive today in some artistic coteries – postwar American painters wanted a quick escape from its restraints.

They substituted the more attractive freedom of large splotches for the laborious circles, triangles and squares that always obey the cold ruler and compass.

Abstraction is spontaneous: form, volume, object and colour are freed from the constraints of 'painting well'.

**Wassily Kandinsky** is the godfather of this large family. While contemplating a picture by Monet, 'The Millstones', upside down by chance, he discovered abstraction. Suddenly he announced that it was more interesting viewed this way than right side up.

Despite his teaching chair at the Bauhaus, he preferred free forms to the geometric formulas that were so hard to digest even for his good Russian stomach.

**Jackson Pollock** is the undisputed master of this *genre* in the United States. Fifth child of a poor family, he earnestly desired a career, and succeeded brilliantly. Fond of surrealism like the other painters of the group, he practised automatic writing, reducing it to its simplest expression: dripping. He remained faithful to it until 1956, when he was killed in a car accident.

The normal slow speed of producing works bored

Jackson; he reacted by conceiving **Action Painting**. This strategy consisted of pouring cans of industrial paint directly onto the canvas on the ground, while at the same time walking around the work. Remember, nobody had thought of this before. If you look at these pictures attentively, they will remind you of the methodically recorded flight-path of a demented fly on a battlefield.

He himself had occasion to notice an even more unexpected effect: the more the production-time of his pictures decreased, the more their market value increased. With this amount of luck, he really should have become a happy man, but instead he lived in a state of depression, with alcohol flowing as freely into his glass as the paint did onto his canvas.

You could make use of American critic Harold Rosenberg's polite comment: 'The state of pictorial creation reflects the psychic and mental state of the artist, both conscious and unconscious.' But some people consider a collection of Jackson's pictures to be a load of Pollocks.

For **Sam Francis**, space is colour. Lively splotches of paint are spread over his canvas like flowers in a garden, before losing themselves at the pictures' edges, in more recent works, to make room for the central white space. In a funny paradox, the Parisian critics called it 'Signifying abstraction'.

Though people generally love to recognize the well-known, it is still true that a puddle of water, a handful of earth scattered on the ground, or the pattern of tree-bark are no less real than a hat or an umbrella, and often more interesting. Abstract expressionism's great merit was to make that clear to everybody.

Besides, as in a psychological Rorschach test, the spectators always think they are seeing something in an abstract work of this type, and that makes everyone happy.

Although his approach to picture composition is very

29

demanding, **Mark Rothko** is one of the great American masters of the abstract. It is therefore a must to admire him, even if you don't. It's simple to recognize his pictures, composed as they are of two or three coloured rectangles, with overlapping contours, on gigantic surfaces. Think of a desert where the horizon and the spectator's gaze become lost for ever. This tremendous need for purification unfortunately led him one day to commit suicide in his studio. Remember, he believed that the only valid subject had to be tragic and timeless.

You should stress the important exhibition of his works at **Peggy Guggenheim**'s no less important **Art of the Century** gallery, and of course prefer his last paintings in black and white. Nicely named 'Chapel Paintings', they were destined for a religious building and look different in colouring from the rest of the *oeuvre*. Few people today appreciate black and white since the invasion of the media by colour, so you will be taken for a real aesthete whose austere taste is proof of great ability.

If, despite all your efforts, abstract art still leaves you cold and you want to make this known without sounding an awful traditionalist, quote **Francis Bacon**'s judgement of it: 'Everything in art appears cruel, for reality is cruel. This, perhaps, is why so many people like abstraction, because one can't be cruel in abstract art.'

Neutral and ornamental, executed on huge surfaces, this type of painting inevitably lent itself to the decoration of banks, offices and the reception areas of industrial companies. When businesses were being modernised, it became an original way to paper the walls.

Jean Cocteau noticed this in his time: 'Abstract painting, once so revolutionary, has now become official and commercial. Why? Because the eye is lazy, and people don't like asking themselves questions. They insult the abstract painters in the worst possible way by buying an abstract canvas to match the fabric of an armchair . . .'

# Pop Art

A trend mainly aimed at convincing the public that
nothing else really exists in art and life except what is
shown by advertising and television.

As **Andy Warhol** declared: 'Pop artists made images that
anyone walking along Broadway could recognize in a
fraction of a second – comic strips, picnic tables, men's
pants, celebrities, bathroom curtains, refrigerators, Coca-
Cola bottles – all the things of modern life that the
abstract Expressionists tried so hard not to see.'
  The more you see these images, the less you look at
them. You really have to multiply and enlarge them to
cosmic dimensions before people pay them attention.
  Pop Art is a western form of culture for 'the people', that
is, the consumer. Bluffers will explain that, contrary to
what most people think, it was born not in the USA but in
London. The term was invented by the English critic
**Lawrence Alloway** who helped to found the **Indepen-
dent Group** of London's **Institute of Contemporary
Art**. During the 50s this group organised exhibitions such
as 'This is Tomorrow'. By sheer coincidence, portraits of
Marilyn Monroe were already on show there. **Richard
Hamilton** showed a collage whose title carried the new
advertising optimism on which the movement centred:
'Just what is it that makes Today's Homes so different, so
appealing?' Looking at Pop Art, it's very hard to guess.
  Pop artists paint what everybody knows and sees, even
if one prefers to forget it. They have created the art of
stating the obvious.
  You could take the line that advertising illustrators in
commercial firms remain the people who are best suited to
choosing and creating this specific popular culture. The
unforgettable success of **Andy Warhol** provides ample
demonstration of this. Of Czech origin, born Andrei

Warhola in Pittsburg in 1931, he had a stunningly successful career in advertising before painting made him even richer: 'I started as a commercial artist, and I want to finish as a business artist.'

He was especially successful in proving that painting could become more commercial than advertising, which had not been obvious until then. Cans of soup were one of his favourite themes because he loved to drink them. They appealed to him as much as the landscapes along the Seine appealed to the Impressionists. He also painted a series of dollar bills, and portraits of Marilyn Monroe, James Dean and Mao.

Like many great modern artists, Warhol had an obsession with speed. He first projected photographs onto canvas, but as this didn't work fast enough, he started printing them directly onto the canvas, and paid others to help him.

As you want to appear original, call attention to his series of abstract paintings made, no doubt at great speed, with jets of urine projected onto a canvas prepared beforehand with an acid base. Then cite him: 'If you want to know everything about Andy Warhol, just look at the surface of my pictures, and look at me, I'm there. There's nothing behind it.'

Suggest that you simply can't wait to go to Pittsburg to see the great museum that his native town is to bestow on its child prodigy of 'popular art'. It doesn't yet exist, so you are on safe ground here.

**Roy Lichtenstein** remains Andy Warhol's only real rival in the field. On a colourful background of enlarged printer's dots, Lichtenstein depicted banal comic strip figures blown up to the maximum. For a while they were both working, albeit separately, on items from comic strips. When Warhol saw his colleague's work, he quickly changed subject, fearing the competition if they continued to deal with such a compromisingly similar theme. To

really succeed you have to be different at all costs.

All you really need to know about **Jasper Johns'** work are his targets, coloured numbers, and American flags. These make him the most expensive American painter on the art market, which is his main achievement.

As for **Robert Rauschenberg**, he asked himself lots of questions, had plenty of things to say, and often changed style: as a result his complex work is easily forgotten. It is he who conceived **Combine paintings**, in which collages are mixed with paint.

His concept of art looks more like philosophy than advertising: 'Painting is a close relationship between art and life; I try to place my work in the gap that exists between the two.' You could say that the absence of the commonplace in his work almost looks like a fault.

# Op Art

If Pop Art is interested only in the image, Op Art is primarily interested in luminous signs.

The Hungarian painter **Vasarely** was one of Op Art's founding fathers. You can see his kinetic panels of multicoloured geometric compositions on the walls of most European cities. They stand out like a little vertical green space in the midst of black industrial smoke.

He was followed in this work by his son **Yvaral** who chose an equally funny kinetic anagram as a name. Op Art's aim isn't merely to offer a new social environment, but to change the whole of human behaviour.

As a bluffer you tell everyone that, when passing through the Swiss clockmaking town of La Chaux de Fonds, you were astonished by its contemporary kinetic carillon, as your love of winter sports never exceeds your thirst for modern art. What could be more admirable – and more rare – than an educated sportsman?

# QUOTABLE QUOTES

Use the following quotes when all other topics of conversation about painting are exhausted.

'It's a matter of total indifference whether I did these pictures, their main creator is today.'          Robert Rauschenberg

'There is no painting, there are only pictures; as these are not sausages, they are neither good nor bad.'          Samuel Beckett

'I search all art in vain for one work that is equal to the women I've loved. My painting has never been anything other than the image of my life.'          Francis Picabia

'An artist's true talent consists of convincing others that his fads are an absolute necessity for them.'          Pablo Picasso

'No work destined to become a classic can ever look like the classic works that preceded it.'          Juan Gris

'Instead of helping art to blossom, official art turns it sterile . . .'
                                                        Jean Dubuffet

'They became painters because they knew that there are so many things one can never say.'          Rainer Maria Rilke

'Where an artist sees a beautiful form, coarse people see only nudity. Beauty is no more in need of ethics than ethics are of art.'
                                                        Camille Saint Saens

'An artist doesn't create a work, he discovers it.'
                                                        André Malraux

'Nowadays nobody dares to criticise anything anymore; this must change.'          Pablo Picasso

'Drawing is the primitive form of writing.'          Pierre Alechinsky

'Art must shock.'          Karel Appel

'The greatest art of all is pastry-making.'          Thomas Bernhard

# ART AS BUSINESS

## Galleries

Picasso wondered what would have happened to Cubist painters if their dealer, **Kahnweiler**, had had no business sense. Andy Warhol provided a clear answer: 'Art is business.' Galleries of modern art play an active role in achieving this goal.

Two major categories sum them up:

1. Those that live at the artists' expense
2. Those that support them.

The second category is by far the most sought after. There is a third category of honest but modest galleries showing new painters they like, but they are out of place in this book since they practise very little bluffing.

The first group is the biggest and the least interesting. These galleries ask huge sums for their services, and exhibit the most conventional works to avoid upsetting their clients' banal tastes. Since many artists would rather starve than realise that they aren't gifted at all, the galleries continue to mine this rich seam in exchange for sweet illusion.

The second category includes the most famous galleries, handed down for generations from father to son. The best of them make and break artists and the art market. All you have to do is belong to them; their doors open like magic and, hey presto, from being a complete unknown, you suddenly become an important representative of the art of your time.

Thus, the key question in this field is not 'What kind of painting do you do?' but 'Who is your dealer?'

The more famous painters a gallery shows, the more quickly its chosen new artists are supposed to join the ranks of the truly prestigious.

Most of these galleries have a well-established aesthetic style, and often select those artists who come closest to their aesthetic choice. They deduct a high percentage from the sale of works, but there are still considerable benefits in doing business with them, because:

- they fix a top price, and make every possible effort to find buyers for the most unsaleable items which they declare beforehand, of course, to be works of genius.
- they sign up their lucky painters with contracts guaranteeing them an appreciable income and a certain amount of fame. Some even provide their artists with studios.
- through the impact of their own renown, they persuade their clientele to accept what it has obstinately refused to accept until then.

The biggest drawback to this system, however, is exclusivity. Artists must follow the rhythm and type of exhibitions chosen by their dealer. They lack any freedom to do as they please.

Most galleries are, by necessity, international, with branches throughout the world. From New York – London – Paris they are now springing up in Tokyo and Barcelona too, bowing to unexpected new economic trends.

Big galleries gain their prestige above all through huge budgets for marketing, with sometimes one or two million dollars annually devoted to advertising and to participation in international fairs where they can afford enormous stands. Bluffers are greatly attracted to some of the most important events: **the Chicago Art Fair**, **the Frankfurt Fair**, **the F.I.A.C. at Paris**, or **Madrid's A.R.C.O.**

The promotion of new, attractive young artists is largely financed through the sale of a few modern pictures by famous deceased artists. Some dealers consider that

they've made their fortune with the pictures they haven't sold in the past. If they put one of these works on sale today, they can buy a new villa. Some are so powerful that they even choose their collectors.

## The Opening

The **opening** is the focus of artistic life.

When attending, guests must pretend to be fascinated by the artist and his work, while hiding the fact that their real interest is in meeting the influential people present. The painter, to show off his fame, must talk about his numerous marvellous exhibitions, past and future, mentioning New York, San Francisco and Tokyo if possible. You will listen politely with suitable admiration, while trying to catch hold of another drink.

The Dutch painter **Bram Van Velde** said, 'All these exhibitions . . . People hold out their hand to you, and when you go to shake it, they've already gone.' An atmosphere of such sincerity leads some artists to flee their own openings for fear of meeting their friends.

The more people you know, the more important you seem. You should therefore attend an opening accompanied by lots of relatives, to be sure you don't run out of people to greet.

The golden rule at such shows is: never look intimidated. Since collectors are those who are greatly sought after at such events, anybody wanting to buy a work of art becomes the most important person present. You have two foolproof methods:

- avoid useless expense by going into ecstasy for an hour in front of a picture, knowing it's already been sold, and complaining about being too late to obtain it
- promise to come back without fail in a week's time to make your final choice with someone else.

Lovers of modern art like to make their audience believe that their mere presence is an event in itself for the gallery. Curiously, many succeed in this, especially if they know how to project a lofty exterior. You should make straight for the artist or the gallery director and, as casually as possible, utter a string of banalities dressed up with lots of compliments.

If you dislike the canvas, you praise its colouring or composition. If you can't tell what the picture represents, you find it 'original'. If it looks run-of-the-mill, you call it 'harmonious and well structured'. Always stress the artist's great originality; this will surprise and please your audience when it's starting to tire – art is a terrific cure for tedium.

Alternatively ask for a catalogue murmuring something about 'doing a piece on your superb exhibition tomorrow'. Then walk around looking haughty, cold and distant, and you'll pass for a born critic. Since critics rarely deign to stir themselves you may not have any real competition.

Every person practised at the game signs the gallery's visitors' book. Most people strive for the most complicated expressions of praise imaginable. But people of note – or at least those who think they are – merely put their signature. It's supposed to mean something in itself.

You should mention a visit to Paris's **Patrice Trigano gallery** (known for his Brauner and Hartnung exhibitions) or **Lelong gallery** (the French dealer of Bacon). Of course you're acquainted not only with the **Marlborough gallery** (the English dealer of Bacon) in London, but its counterpart in New York, as well as that city's **Leo Castelli gallery** (whose patronage of Warhol, Pollock and Lichtenstein made it, and them, famous).

The bluffer's hard work is simplified by the fact that city galleries are located close to each other in special arty districts. Here you can keep yourself informed of the latest

art trends more surely and quickly than in any state repository. And you will impress those who think that it's enough simply to visit museums.

# Collectors

Every child likes to collect stamps. People who get rich prefer to collect works of art. Most art lovers look after antiques; but if your passion for old watches or collectable dolls is exhausted, you can venture into the search for modern pictures.

The field has grown enormously in recent times; in this area, short-term profits are the most dazzling.

Some American collectors use the scattergun approach, buying as many contemporary works as possible at low prices, in the hope that some of them will quickly increase in value. All collectors dream of acquiring for next to nothing a picture that will one day sell for a fortune. Most, when faced with the opportunity to choose the work of an obscure painter, are so afraid to take the risk of buying something they actually like although it lacks value, they prefer to wait and spend money on the better known stuff that's sold everywhere.

This is what happened to Chagall's works which, twenty years ago, could be acquired for a few thousand pounds but are now way beyond the reach of most mortals. As young painters are aware of this situation, they know they must sell their masterpieces for the highest possible prices from the start, since buyers only think they've made a sound acquisition if it has really strained their finances.

Throughout the world, galleries remain the greatest collectors. Not only do they create large available stockpiles, they also accumulate them. Like great dealers, great collectors carry on from father to son, and in-

heritance creates huge art dynasties. The increasing number of collectors leads museums to wait patiently for posthumous **donations** instead of filling their halls themselves or taking needless risks.

Artists' widows and children are the main trustees of the deceased's work and quickly become the object of adulation of public authorities in need of donations. Members of the family are thus transformed into celebrities. As with real estate, the value of their property increases over time, and so does their own fame.

Artists themselves live among friends; they offer each other pictures, swop them or buy them. If they meet interesting artists, they can be linked to some recognized trend. In consequence their own prices will rise.

This is one of the greatest contradictions of an artist's career: the more unconventional a painter wants to appear, detached from the trivia of everyday life, the more he has to surround himself with wealthy collectors in order to achieve fame. When you're offering your works for thousands of dollars, there is little point in trying to sell to people on the fringe. Playing a role, meeting influential people is your constant concern; so you remain subject to the goodwill of dealers and public.

Collectors have a wide range of motives, from blissful admiration to simple charity. The artist usually convinces himself that only the former applies in his case. However, the more wordly people become, the less they bother with artists and the more attention they pay to the great collections.

The key factor among the keenest and hence most serious collectors is the desire to make a fortune. To appear educated, to play the aesthete, and create an interesting image for yourself are further reasons for acquiring works of art once you've made your fortune, in accordance with the modern principle: you are what you own.

True collectors have made their mark on art history: they were pioneers who fought for artists against the negative opinions of the critics and museums of their time.

In France, the couturier **Jacques Doucet** was a very early collector of numerous Braques and Picassos. He bought the latter's 'Les Demoiselles d'Avignon' and later tried hard to sell the picture to a Paris museum. Met by a categoric refusal, he sold it with great regret to the United States, where it currently hangs in New York's Museum of Modern Art. This work's return to Paris for an exhibition was seen as a great national artistic event.

You should cite the work of **Albert Barnes**, the founder of the museum in Merion near Philadelphia. A doctor and a friend of persecuted blacks, he became a friend of Matisse, and invited him to decorate the great gallery of his museum with 'La Danse'. He saved Soutine from misery, depression and contempt; at a time when nobody wanted to look at his pictures, Barnes bought dozens of them. This had an immediate effect on Soutine's Paris dealers, who changed their minds as quickly as if they had been given new spectacles.

The fate of many great collections is to end up stockpiled in a museum, with the name of the donor forever attached to his impressive acquisitions. Even those who would like to keep their artistic treasures at home are strongly urged to hand them over to a museum. In France, such a donation enables them to escape paying estate duties. Most folk would rather unload a picture than a large pile of cash. Passion for the useless does have its limits.

To pass yourself off as a keen collector without in fact having any means, take an interest in **etchings**. For a few hundred pounds you can acquire a Bram Van Velde or a work by Dali, depending on your aesthetic taste which you will discuss, of course, as passionately and seriously

as a real connoisseur.

You can never go wrong as long as you choose artists that have already been accepted by others for ages.

# Auctions

Auctions are ideal places for the practised bluffer in modern art to show himself. Here the illusions and crazes of the day are on display; here all manner of psychological motivations can be observed, from the obsessed amateur's furious quest for the item of his fantasies to the businessman's desperation to make an investment. According to one valuer, 'Everything works perfectly here: bankers only talk about pictures, and artists only talk about money.'

Bluffers attend these sales regularly. Some with nothing to do, who want to be seen, pay daily visits to auctions where they study the prices realised, and compare them to the catalogue's estimates. They also like to play the dealer when they decide to acquire a work and then resell it a few months later. They tell all this to their acquaintances, who weren't yet aware that a Pascin canvas was estimated at £70,000 and who therefore think they're talking to an extremely cultured person.

At auctions everyone wants to do business:

- the artist, if still alive, wishes to get the best possible price for his work;
- the dealer wants to make a killing;
- the art lover hopes to get the lucky break of his life while bypassing the expensive middleman.

Modern pictures are particularly prized at auctions: they don't require a great effort of memory, since everybody can remember certain names – the best known ones, and preferably always the same ones.

Sales enjoy a lot of publicity in specialised art maga-

zines and thanks to television news, everyone has heard about the £49 million for Van Gogh's portrait of 'Dr. Gachet'. You don't have to visit a museum to know the value of modern art.

Investors find it far more profitable to acquire a few Jasper Johns, or to put one more Miró in their bank vaults, than to keep endless Toshiba or IBM shares in their portfolios. Shares certificates are not very beautiful, and besides they run the risk of dropping in value. So auction-houses have become an elegant annex of Wall Street. No question of vulgar excess yields here; investors can display their passion for culture while avoiding fiscal taxes. In many countries there is total tax exemption on the acquistion of works of art.

Though salerooms are a hive of activity, the most serious clients are those who don't budge: there is a simple telephone link between Sotheby's and Tokyo, and they win the bidding.

Japanese investors are putting together an imaginary museum, and at the same time advertising their companies through these 'sales of the century'. Western countries, finding it more and more difficult to keep up with the bidding, are left wondering why they didn't take any interest in these works earlier.

For the price of a work by Van Gogh you can buy 15 pictures by Rembrandt, in the unlikely event of their being available. At Sotheby's, the current estimates are:

- A Henry Moore statuette                £70,000
- A picture by Hans Hartung              £150,000
- A mobile by Calder                     £200,000
- A picture by Lucian Freud              £450,000
- A picture by Chagall                   £1,000,000
- A little Picasso (Roman period)        £1,000,000
- A Picasso gouache (blue period)        £1,500,000
- A work by Paul Klee                    £2,500,000
- A Modigliani portrait                  £5,000,000

While the happy sellers themselves remain in the background, public opinion loves to revel in these fabulous sums; everybody becomes a bluffer by pretending to be interested. A work of art remains unchanged no matter what price is paid for it – and being aware of prices is easier than appreciating paintings.

Bidding varies from country to country. A painter who is not highly regarded at home may look extraordinarily exotic elsewhere. Estimates are worked out according to a number of highly artistic criteria such as:

- Previous prices.
- Different sizes – there is an implicit price by the metre, as with textiles.
- Different materials: canvas looks much more expensive than paper.
- Technical skills: painting in oils appears more glamorous than a plain pencil sketch.
- The origin of the piece. Aristocratic collections, or those belonging to famous men, flatter the market's vanity.

Collectors compare the price of works in pounds, dollars, French and Swiss Francs. This reveals numerous differences between:

- New York and Paris.
- The months of the year (during holiday periods, buyers prefer to go to the tropics).
- Rainy days and dry ones.
- The neighbourhoods where the auction-houses are located, some being more stylish than others.

The buyer takes precautions against fakes as best he can. This means examining the picture's provenance, its pedigree. The safest bet is a work acquired by the seller from the painter himself, or from his gallery.

You will claim to go regularly to Sotheby's; this is where the most important sales of modern and contemporary paintings take place. When you travel abroad, you naturally wish to attend some sale whose outcome is of crucial importance to you. It depends on the scope of your bluff and your social standing whether you aim to acquire a picture or a drawing at this sale. In any case, nobody will ask to see it on your return; people always forget what you tell them. So you're not running any risk. The important thing is to appear to take part in great events.

# Cultural Patronage

In the past, a patron was simply looking for glory and trying to associate his name and his innumerable manorial residences with the most grandiose artists of the time; it helped him to tell his houses apart.

More recent and more discreet patrons were great collectors who sincerely wanted to help the artists, like **Gertrude Stein** and the Cubists. This American writer even had the courage to get her portrait painted by Picasso when people were still finding it hard to look at his works. **Zborowski** played a pretty similar role of cultural nursemaid to the artists of the Paris School.

This kind of attitude is long gone. Modern patrons have given up asking artists to celebrate some divine cult or other. They rarely feel passionately about art. Today Soutine and Shell come together at the whim of a marketing operation. Through elitist advertising such exhibitions are aimed at the 'happy few' who are able to appreciate, understand and above all buy – not necessarily a picture, but maybe an elegant car.

If you have money and don't wish to remain simply a donor, you create an artistic **Foundation** and give it your

name. This entitles you to the pleasure of:

- giving out prizes
- placing famous people on your Committee of Honour
- hearing praise heaped on the jury you've chosen, and getting it photographed by the press
- enabling certain artists to take a world trip thanks to the grant they've been awarded, assuming they don't spend it on new kitchen furniture
- organising seminars and conferences to which you invite prominent personalities that you've always wanted to meet
- becoming, in the eyes of your peers, a remarkable and generous person without even having to leave your own milieu.

Foundations try to manage their revenue as well and as pleasantly as possible, collecting fresh funds by organising sumptuous cocktail parties to which everyone wishes to be invited even though guests are expected to hand over a cheque before departing.

Candidates for this veritable manna from heaven are becoming increasingly numerous, given the growing stinginess with which public funds are now distributed; like the unemployed, the number of artists is constantly on the rise.

The biggest American foundations, whose main aim is 'human progress', may give financial help to a boxing match as readily as to an exhibition. Patronage expresses, above all, the idea of freedom and private enterprise. The more art is official and under state control, the fewer patrons you see. Just try and find one in Albania.

In the United States, foundations represent public interest. Bankers manage gigantic sums that are administered by influential people. Artists and intellectuals from all over the world apply to them freely. A few

letters of recommendation suffice. Not only do they have no fear of new applicants, they actively encourage them: a directory of American Foundations is available for this purpose, and even a Center of Documentation on American Patronage in New York.

Among the most prestigious artistic foundations are Washington's **Smithsonian Institution**, and the **Getty Foundation** in California. Most American museums are private foundations which finance their acquistions with the help of other private foundations. When they don't have the means to make new acquisitions in the face of mind-boggling price-rises, they simply sell off some works that are clogging up the storerooms. This brings them back, after a long snooze, onto the commercial circuit.

Since art is universal and American nationalism not too highly developed, these foundations invest their funds abroad very generously. Some prestigious French historical monuments and Claude Monet's house and garden at Giverny were restored thanks to gifts from American sponsors who didn't speak a word of French.

In Britain some foundations are exempt from income tax, which makes their task a lot easier. In France, however, foundations cannot be created without first obtaining the state's blessing. They have to be officially declared 'of public utility' – which is no picnic – and endowed with untransferable capital and such severe rules of operation that candidates inevitably prefer to do something else with their money.

Patronage is relatively new in France, though the state resorts to it to promote its own cultural aims. Sponsors then have a choice between supporting some prestigious official activity or helping unknown young artists. They usually find it an easy decision.

Sometimes people become unwitting sponsors. In France it's possible to oppose the export of a work of art by its owner, even if the owner is not French. One collector

recently had to give an important work by Picasso to a French museum in exchange for permission to auction another one on the international market. He even bought the first one specially for this purpose. Love of art is boundless.

You mustn't fail to follow the activity of Japanese foundations which are currently investing heavily in the art market, especially those funded by insurance companies. Already rich as Croesus, they're also becoming famous by creating sumptuous museums. Without batting an eyelid, you can mention a couple of great Japanese museums – which represent some imposing foundations: **Yamatane** and **Idemitsu**. They're so far away that it is most unlikely anyone will ask embarrassing questions.

In addition, you particularly enjoyed the modern architecture of the **Gulbenkian Foundation** in Lisbon. When in Paris, you always love to wander into the pretty villa, covered in chinoiseries, that has been transformed into an independent annex of a modern art museum: the American **Mona Bismarck Foundation**, located on the Quai de New York. It's free, and they even greet you in English there.

# THE SPECIALISTS

## Art Critics

There are two types of art critic: writers and journalists. Some of the latter would have been failures as painters, so they make severe judgements about the artistic work of others. As **Degas** said about them: 'They explain painting without understanding it'. Poets and writers, being creative themselves, are closer to painters, and less harsh or prejudiced towards them.

Writers who were illustrious art critics include **Jean Cocteau**, **Max Jacob** and **Apollinaire** (drop into the conversation that his real name was in fact Wilhelm Apollinaris de Kostrowitsky, if you can remember it yourself).

A critic's fame lies primarily in the print-run and renown of the publication he writes for. His main aim is to strive with all means at his disposal to publish a lot about well-known people in fashionable journals. This brings plenty of honours, but not a great deal of cash, so he usually has to devote most of his time to another profession, a fact which inevitably makes him bitter and uncompromising.

Once he is editor of an art journal, he's sometimes asked by arty politicians to help promote national productions; courted by public authorities, he's then sent abroad, to art events in Seoul or Brazil, at the head of artistic delegations to show off national painters of his own choice. Some critics found movements just by putting together a few artists who've never met before, under a name borrowed from general art history's terminology, but preceded by neo-, post-, trans-, etc. However, it's one thing to launch a movement, it's a lot harder to keep it going.

Some critics may give new titles to works of art: "'Les Demoiselles d'Avignon'! That name really irritates me,"

said Picasso, "Salmon [the art critic] came up with it; you know full well that I originally called it 'The Avignon Brothel'." The more critics get to act, speak or write, the more an artist is expected just to display his work and keep quiet.

As the history of art is the history of painted fantasies, art criticism has evolved to somewhere between pure invention and borrowed scientific jargon, eg:

'Thus in his most important works the artist, far from emphasising the aesthetico-formal contemplation of a manufactured form's singularity, applies himself on the contrary to dissolving singular properties through serial connections to the benefit of an aesthetic of the continuum of addition which takes value away from every added term.'

Artists themselves, immersed in this universe of speechifying about creation, have in turn begun to construct their own aesthetic theories. You can be sure that the more obscure and philosophical their speech, the more meaningless or ordinary their works are. This led Matisse to say 'painters should cut out their tongues in order to express themselves only with their brush.'

To resemble a critic, which is often a useful self-defence in society, you make categorical cutting judgements of this sort: 'Braque is obsessed with style, but the obsession to create is Picasso's.' You select a vague impression which you then apply to the whole of an artist's past and future work.

It isn't enough to be fond of exhibitions and short art films; as a bluffer you've also read with relish – and of course in the original French – the book on the *Painters of Montparnasse* by **André Salmon**, critic and chronicler of the 1930s. If you're not a polyglot, you cite the biography of **Man Ray** by his friend **Roland Penrose**, also a

surrealist painter; or **John Russell**'s work on **Bacon**, whose company he kept for seven years. A glance through the list of publishers Thames and Hudson will help you stay up to date on the art front. The trick is not to read a book but to be able to talk about it at the right moment.

Few people are truly interested in critics; they prefer painters. So armed with a basic knowledge of art criticism, you'll sound like a real scholar.

# Museum Directors and Curators

All curators of modern art museums dream of becoming Chief Curator and, if possible, Director. To achieve this a curator needs excellent connections, preferably political ones, to make him look more influential than his colleagues. Three outstanding directors will be long remembered:

- **Alfred Barr**, founder of New York's M.O.M.A.
- **Willem Sandberg**, director of Amsterdam's Stede-lijk Museum.
- **Pontus Hulten**, director of Stockholm's Moderna Museet, who set up some colourful sculptures by **Niki de Saint Phalle** next to this building. He became an advisor at Paris's Beaubourg a few years later, and got the same French artist to create a fountain there. A continuous circus show, every competent bluffer knows it well, and his children can also be trained to become accomplished bluffers at a very early age while having tremendous fun at the same time.

It has been said that in a perfect museum the curator's tasks would be:

- to acquire works (trends, periods, rather than fellow countrymen, friends or relatives);

- to rectify the errors of predecessors;
- to keep collections together and conserve them.

Unfortunately few manage to cope with such an ideal.

Promoting exhibitions that are more masterly, more prestigious and more elitist than those of their colleagues is the curators' chief role. This offers the advantage of boosting their own career while enlightening humanity with their knowledge at the same time. Bluffers should try to refer not to the exhibition of such and such a painter, but to that conceived by some **commissioner of exhibitions** or other.

An exhibition's criteria vary according to the curator's interest in classification: big paintings, little paintings, painters of the '20s, artists from Patagonia or ecological art. Or he may just select a vague idea like 'The Five Senses' or 'Sorcerers'. Anything becomes possible as long as you have a museum's finances to launch it. It's finding a new angle that's the difficult bit.

Some curators stand out through the quality of their retrospectives and choices, while others become famous for their refusals. The curator Pontier swore that in his lifetime no picture by Cézanne would ever enter the museum of Aix en Provence, the town of the painter's birth. More recently, the donation of beautiful **art brut** by **Dubuffet** was refused by French specialists. So it now occupies a place of honour in Lausanne where, throughout the town, the museum is as clearly signposted as the railway station.

A German collector of French painter **Jean Fautrier** wanted to sponsor the construction in France of a museum entirely devoted to this artist. As the offer was turned down by the cultural advisors, the museum was built on an island in the Rhine near Düsseldorf.

No one can ever hope to remember all the curators' names, so there's no need to try. But you must know the names of the big museums of modern art they control.

Apart from the **Tate Gallery** and **Beaubourg**, you're familiar with the **Chicago Art Institute** and the **County Museum of Los Angeles**, New York's **Museum of Modern Art** (MOMA) not to be confused with it's equivalent for American art, the **Whitney Museum of American Art** (MAA), also in New York, and when passing through that city you make a bee-line for the **Guggenheim**.

In **Berlin** you pay hommage to Mies van der Rohe's exquisite glass **Modern Art Museum**; in **Brussels** you visit an almost invisible **Museum of Modern Art** underneath the Museum of Ancient Art. It's a bit more sober than Beaubourg and most modern artists.

The boom in modern art museums continues at an extraordinary pace so your love for the most lively of them should similarly never stop growing. You take a particular interest in the activities of the new Spanish museums, since you can be sure, at the same time, of having pleasant holidays in that country. Although Spain has produced some gigantic figures in contemporary art, it still occurs to few people to seek them out in their country of origin.

**Baron Thyssen** decided to transplant his famous Swiss museum from the **Villa Favorita** to Madrid, despite the insistent pleadings of not only London but especially Bonn, the capital of his native land, where politicians complained bitterly they had nothing of any interest to show important guests visiting their town.

The real enthusiast scores points by mentioning the **Reina Sophia**, Madrid's majestic contemporary art museum. When visiting the coast, you naturally stopped at the **I.V.A.M.**, Valencia's new museum of contemporary art, an original complex of several galleries, two museums and an institute of modern art history; and never miss an opportunity to talk about Barcelona's **Picasso Museum**, the **Miró Foundation**, or the **Dali Museum** at Figueras.

And on top of all this, never forget that modern art is still your passion.

# Experts

Works of modern art pop up like mushrooms, and consequently so do experts. The hardest thing is to keep up with the speed of the movement while maintaining the necessary perspective.

The best experts are gallery directors; they are the first to hear about big deals, and their word is worth a fortune on the art stockmarket. A true expert – to prove himself to others – publishes as soon as possible after an artist's death, a **descriptive catalogue** of the artist's *oeuvre*, so prices start to rise inexorably. If some work is not included in this formidable document, it will be extremely difficult afterwards to prove its authenticity, or even its existence.

The key to their expertise is often the examination of the **artist's signature**. Unwittingly they become graphologists too. Bluffers should know that some artists make the expert's life difficult by suddenly deciding not to recognise a picture from a period in their lives that they now consider passé.

If they really wanted to, these wise men of modern art could spend their whole life **exposing fakes**. Recently, 4000 fake canvases by Picasso, Chirico and Dali were seized in a single gallery in Rome. An artist may even discover – as Miró did one day in an American gallery – that all of his works on show in the gallery are fakes. Things got even worse for Miró when, to his amazement, he was taken to court and had to prove he wasn't lying.

Today, everyone thinks he's a specialist, an expert or, even better, a technical adviser on one thing or another; so the practised bluffer will have no trouble at all in declaring that he's a friend of one, that he is one, or that he will become one very soon.

# ART AND THE WRITTEN WORD

## Artists' Memoirs:

The best source of information. They're a real pleasure to read, and one is always astonished to find that a great artist isn't just skilful with his hands but can also think intelligently without any help from the critics. Until recent years such books were buried; they were forgotten, out-of-print volumes gathering cobwebs in university libraries; but lately there's been an explosion of published artists' memoirs, thanks to the fabulous price-rises on the modern art market.

As a bluffer you absolutely loved *Du Spirituel dans l'Art* by Kandinsky, the writings of Matisse, and you're familiar with the publication in Paris of Picasso's writings, a book so monumental that it's far easier to read than to lift.

## Art Books:

The more famous an artist becomes, the more gigantic volumes are published about his works. Glory leads to more glory, so some artists blow their own trumpet by publishing books on themselves. The most beautiful are produced in Italy or Switzerland. But sometimes, young publishers manage to bring out huge books on contemporary painters who are entirely unknown to the public.

The most renowned critics write artists' biographies; unfortunately these usually get bought as Christmas presents. Most people just like looking at the pictures, and forget to read them. Such books must, above all, be in colour to make an impression as a gift, and they're generally bought at sale-price after being remaindered.

## Art Magazines:

Since these are about as much fun to read as the books of
Emmanuel Kant, their illustrations are very necessary.
Art magazines launch the latest trend. In the past, they
used to fade away along with it; but today they keep going
and put pressure on artistic movements to remain 'up to
date'. Painters make every possible effort to appear in
them, and bluffers to read them.

As a true cosmopolitan, you adorn your living room
with strategically scattered issues of such publications,
preferably foreign ones like *Art in America* and *Art
Forum*, the latter founded in San Francisco. They
fascinate you as California does, and for similar reasons:
luxury is attractive to everybody.

## Exhibition Catalogues:

Exhibition catalogues are intended exclusively for schol-
ars with big bookcases who want to know why Modigliani
painted this portrait, whom it represents, who owned the
work before it entered a public collection, and which
museum has it now. Few are interested in this kind of
detail, but it becomes an obsession for the odd fanatic. The
bluffer, always in a hurry, much prefers the summaries of
fashionable exhibitions of the sort done from the cata-
logue by their favourite daily newspaper.

# MORE NAMES TO KNOW

### Francis Bacon
English painter as famous as the English breakfast.
There is certainly an enormous quantity of flesh in his
works – though no fried eggs as in Dali. He has produced
dramatic portraits of his numerous acquaintances, done
in slices – not exactly a fashionable style; they clearly
weren't commissions, because his people don't smile. Like
most great modern painters, he is self-taught.

### COBRA
A group of painters in northern Europe (Copenhagen,
Oslo, Brussels, Amsterdam) that constructed a colourful
African snake long before the creation of the European
monetary snake. In 1945 they were the only young artists
who understood that something really had to happen in
the world of painting after the cataclysm of the recent
slaughter. Consequently, they took no interest at all in
pretty little splotches and pleasant landscapes. Among
them were **Alechinsky Appel** and **Corneille**. Their
greatest desire was to daub children's drawings on top of
Mondrian's pictures – an idea all the more praiseworthy
since it came from the Dutch members of the group.

### Henri Matisse
He loved wavy lines, flat forms, and happy subjects like a
Romanian blouse, an aquarium or dancing. He is easy to
distinguish from Picasso. Unlike him, he never became
French through naturalisation – he already was French.
He disturbs the viewer less than Picasso because he must
have been an incorrigible optimist, and it shows. Towards
the end of his life, no longer able to paint, he decided to cut
up coloured paper and stick it on a white surface.
Specialists call this series of works *The Paper Cutouts*.
The style was destined to survive forever, since every

primary schoolteacher in the world makes children do the same today.

## Joan Miró
Interpreter of tiny starfish, minute flowers and grains of sand, he is the opposite of those painters who are only moved by serious subjects or noble compositions.

A most precocious artist, his first masterpiece was a multicoloured tortoise painted at the age of 7. He obstinately continued to observe everything that normally goes totally unnoticed, and to paint in the same way. Bluffers should point out that the Japanese love Miró because he reminds them of the ideograms of their childhood.

## Henry Moore
Happily forsaking coal for charcoal and metal, this son of a Yorkshire miner made studies of the miners' lives in a series of drawings. Above all he loved gigantic bronze women; he also drew elephant skulls, which gave him the idea of putting holes in his human figures. This brings them closer to the skeletons they would have become in any case if they'd been real. His series of **'people taking shelter'**, during World War II, is heartbreaking – like his sad, fat sheep waiting to know with which sauce they'll be eaten.

## Nicolas De Stael
One of the greatest European abstract painters, he was a Russian living in Paris. Born in St Petersburg, where his father was deputy-governor of the Peter & Paul Fortress, he was predisposed very early to abstraction, since it offered the best possible escape. Now and again you can make out a few motifs in his works: an orchestra, flowers, the sea. The sight of a nocturnal football match had a lasting and illuminating effect on him. However, all this

and glory, too, didn't prevent him committing suicide at 41, though art historians regard him as immortal.

## Bram Van Velde

The Samuel Beckett of painting, he was as lost, fragile, poor and desperate as the people the playwright depicted. Unlike them, however, he was saved in the nick of time by the writer when he was quietly starving to death in a Paris garage. Beckett wrote prefaces for his catalogues and, thanks to him, Van Velde became famous, albeit very late in life. This left him totally indifferent since he believed it was a thousand times better for an artist to be unknown than adored. So to keep his earlier period always in mind, he continued painting in a garage. His abstract pictures have no titles; this helps differentiate them from other people's.

# GLOSSARY

**Art Brut** ('Outsider Art') – The art of madmen, of the unemployed, of pariahs and children, and also of some artists aware that they may well soon become one of the above.

**Conceptual Art** – The art of those who think they're displaying important philosophical ideas in the slightest thing they do, where nobody else can see any at all.

**Art Director** – Someone who really thinks he can manage modern art.

**Official Art** – Anything that can, at some time or another, flatter civil servants and the state.

**Arte Povera** – Odd items that are totally meaningless and utterly useless except for one thing: they bring their creators esteem and cash.

**Bateau Lavoir** (Wash-house boat) – Artists' studios in Montmartre crowded with artists and writers, where Picasso gave modern art a thorough shake-up from which it's never really recovered.

**Installations** – Anything and everything that takes up a lot of space in a museum of contemporary art.

**Land Art** – Piles of sand or leaves; twigs, stones and bits of bark stuck to the canvas; what's usually called a 'return to nature' at a fashionable opening. Can also include the footsteps in snow of this type of artist.

**Lithograph** – Means used by artists to make modern art accessible to mere mortals.

**Minimal Art** – Art which attracts even less people than the number of works on show.

**Museography** – New ways of grouping and explaining works of art in museums by permanently moving them about.

**La Ruche** (The Beehive) – Parisian studios where many artists starved while hoping to become famous one day.

**Salon des Indépendants** – Old-time official Parisian salon where anyone can exhibit whatever he likes. You find the best and the worst there, in exactly the same proportion as in marriage.

**Société Nationale des Beaux Arts** – Former official Parisian Salon. Most painters shared the illusion that traditions here would go on for ever.

**Auctions** – Places where you buy at an inflated price what other people originally sold for next to nothing.

**Collages** – Cunning way of sticking together items from ordinary life which the artist doesn't feel like painting.

**Ready-mades** – The transformation of everyday items into analytical concepts of art philosophy.

**Neologisms** – Terms coined by critics to help the artists believe they are truly original.

**Analytic cubism** – A lot of distortion with very little colour.

**Synthetic cubism** – As above with plenty of colour.

**Realism** – Painting in such a precise way that you can be sure nobody will miss what you want to show.

**Hyper-realism** – As above with obsessive detail.

**Modernism** – From an artistic point of view, another way of prizing 20th century achievements.

**Modern** – Anything you are not yet quite used to.

# THE AUTHOR

Marina Dana Rodna was conceived in 1952 and was first exhibited the following year in Bucharest. She immediately became known to her friends and relations, and even reached her neighbours' ears. She had a harder time becoming known to other people.

She has been settled in Paris since the age of 7, so naturally the French press considers her a Romanian painter.

A painter and psychologist by training, she discovered from an art critic's description of her exhibition in Frankfurt that what she was doing was 'Paintings of the Soul', a poetic term in German, especially if, like her, you don't speak a word of the language.

An addict of Free Figuration, she loves painting animals. She meets them every day in the shape of a Siamese cat and a Marrakesh tortoise that climbs walls. Visitors to her Paris exhibitions often ask her why she paints animals; curiously, they never ask why she paints human beings.

Marina Rodna has published studies on the psychology of art. Her greatest passions are nonsense, chance and fellow feelings. Picasso summed up the situation in this way: 'God is an artist like any other; he invented the giraffe, the dog, the cat; he doesn't really have a style, he's still experimenting.'

# THE BLUFFER'S GUIDES

Available at £1.99 and (new titles* £2.50) each:

Accountancy
Advertising
Antiques
Archaeology
Astrology & Fortune Telling
Ballet
Bird Watching
Bluffing
British Class
Champagne*
The Classics
Computers
Consultancy
Cricket
The European Community
Espionage
Finance
The Flight Deck
Golf
The Green Bluffer's Guide
Japan
Jazz
Journalism
Literature
Management
Marketing

Maths
Modern Art
Motoring
Music
The Occult
Opera
Paris
Philosophy
Photography
Poetry
P.R.
Public Speaking
Publishing
Racing
Rugby
Secretaries
Seduction
Sex
Small Business*
Teaching
Theatre
University
Weather Forecasting
Whisky
Wine
World Affairs

---

These books are available at your local bookshop or newsagent, or can be ordered direct from the publisher. Prices and availability are subject to change without notice. Just tick the titles you require and send a cheque or postal order (allowing in the UK for postage and packing 28p for one book and 12p for each additional book ordered) to:

Ravette Books Limited, 3 Glenside Estate, Star Road, Partridge Green, Horsham, West Sussex RH13 8RA.